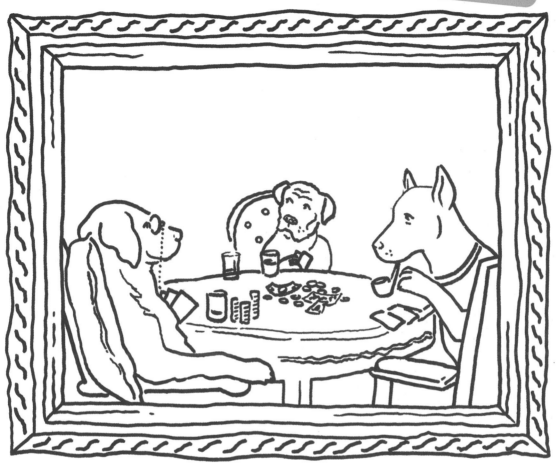

Starring Doodler
Maggie O'Connor

With Guest Doodlers
Deirdre Quinn Burgess
Veronica Calvo
Kevin Cuasay
Michael Franck
Kate Kolososki
Julia Lobo
Steve Martin

Publications International, Ltd.
7373 North Cicero Avenue
Lincolnwood, Illinois 60712
Ground Floor, 59 Gloucester Place
London W1U 8JJ
Permission is never granted for commercial purposes.
Customer Service: 1-800-595-8484 or customer_service@pilbooks.com
www.pilbooks.com
Brain Games is a registered
trademark of Publications International, Ltd.
8 7 6 5 4 3 2 1
Manufactured in China.
ISBN-13: 978-1-4508-0406-6
ISBN-10: 1-4508-0406-3

BRAIN GAMES®

Dare to Doodle

Publications International, Ltd.

Dare to Doodle

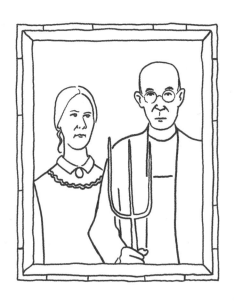

Not an artist? Not a problem! When you *Dare to Doodle*, no artistic ability is required. Tapping into your undiscovered creative side has never been easier!

Why should the left side of your brain get all the fun? Just grab a marker, relax, and let your right brain express itself. Unlike left-brain exercises, doodling has no wrong answers.

The following pages are filled with different doodle activities and prompts. To give you a good start, we've already begun some of the "work" for you. Just complete the doodle activities and make them your own!

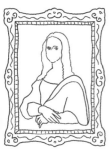 ← Add your own twist to a famous painting, like the Mona Lisa

Make something special out of a simple squiggle →

Finish a fun party scene →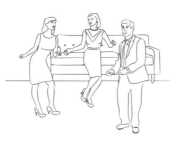

 ← Complete an interesting pattern

Design and doodle your dream house →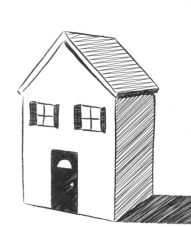

Doodle on a dollar

Complete and caption a funny cartoon →

It's all inside! Get ready for hours of fun, fueled by your own brain power.

Finish the pattern across the page.
Feel free to add more detail, too!

inish the starry sky. Add some comets and planets into the mix, too.

Draw what's going on inside this building.

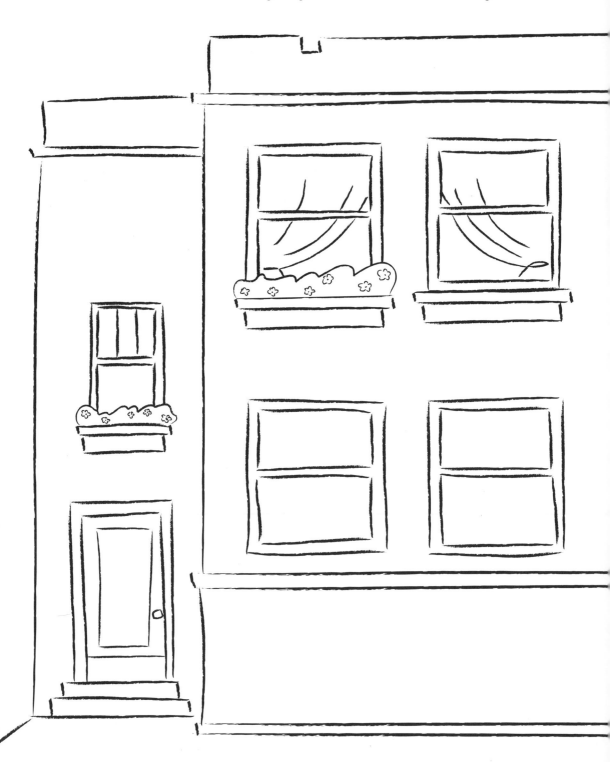

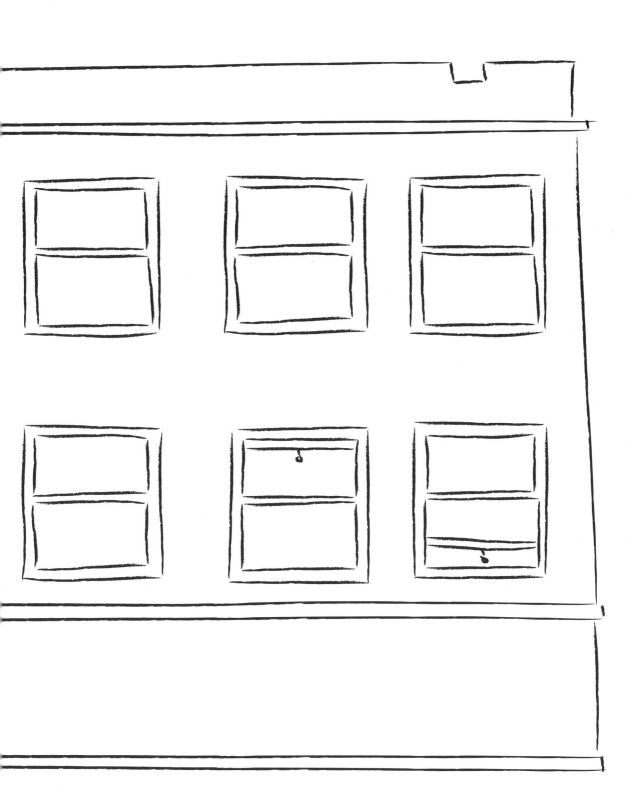

Add your own twist to this famous piece of art. Where is it hanging?

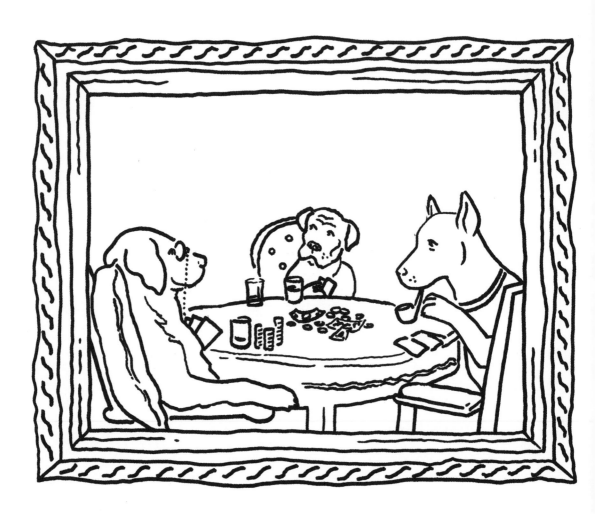

Now create your own masterpiece!

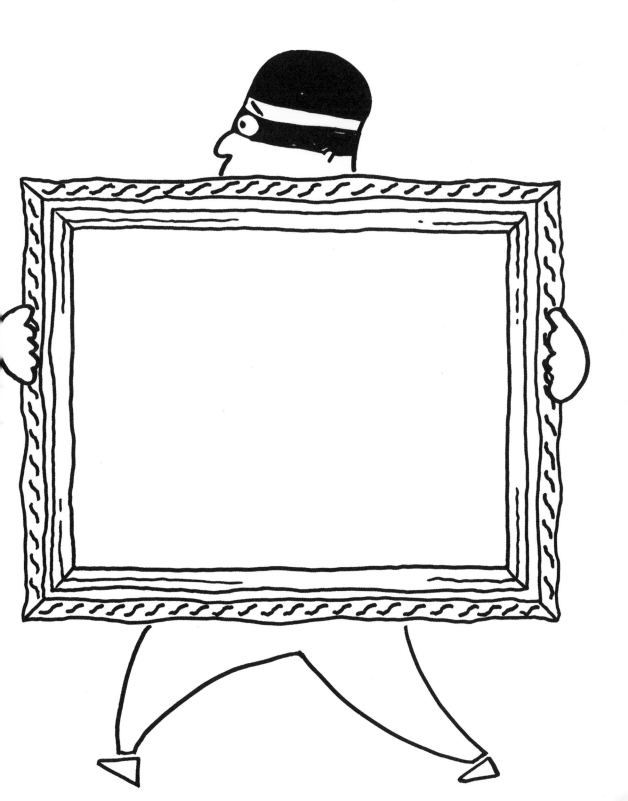

What do you see? Turn this squiggle into something else.

FREE SPACE

Finish the alphabet.

Map out the globe.

Add to the scene, then write what the castaway is saying.

Add your own twist to this dollar.

Doodle on these dollars.

What else is inside the aquarium? Is someone looking in?

FREE
SPACE

Design your own monuments for something or someone close to you.

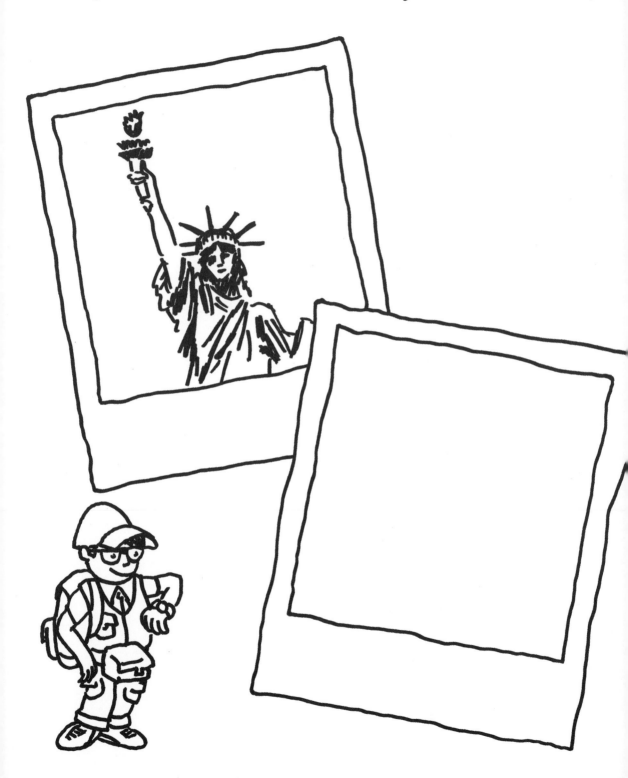

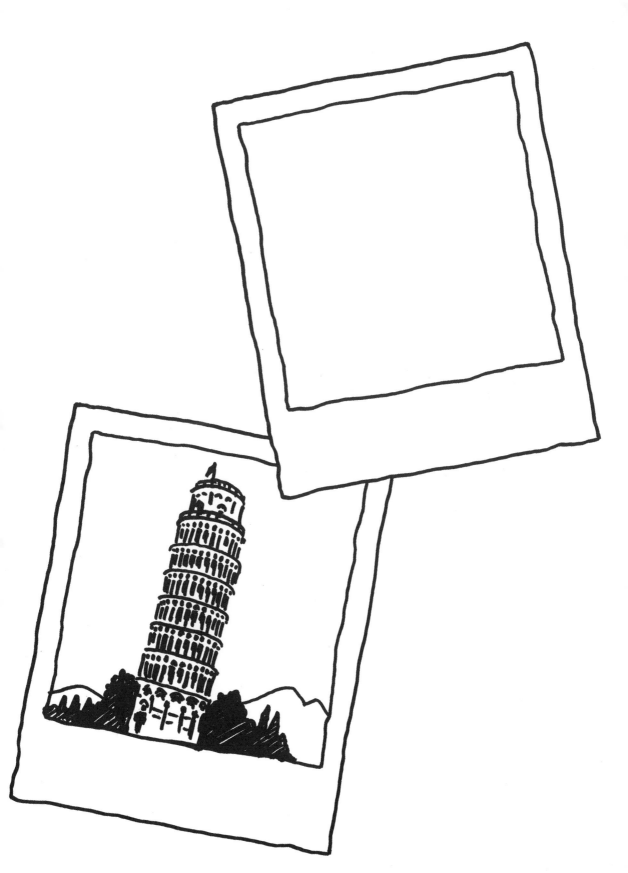

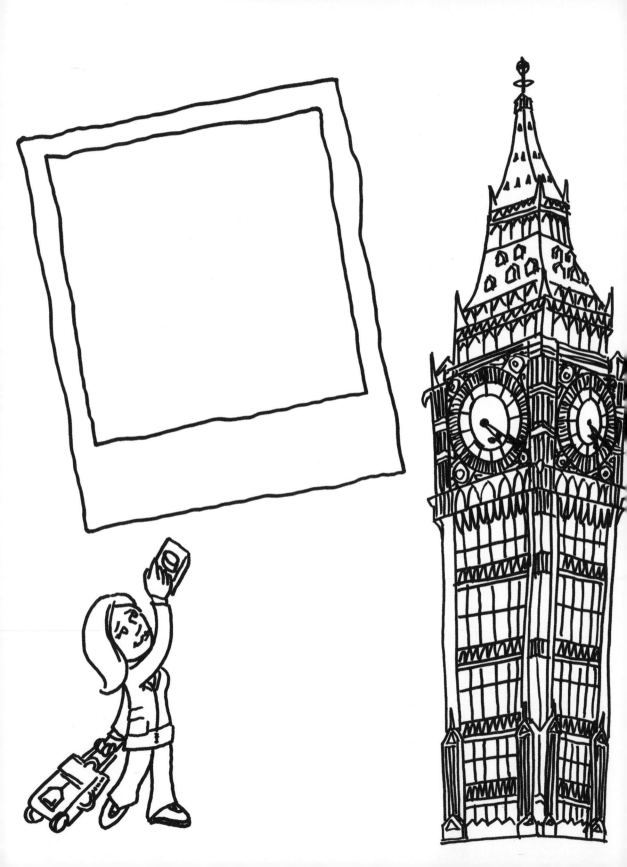

What do you see? Turn this squiggle into something else.

Hieroglyphics tell a story through simple pictures.
Use shapes to tell a story without words.

Use the next few pages to create some more hieroglyphics.

finish the house.

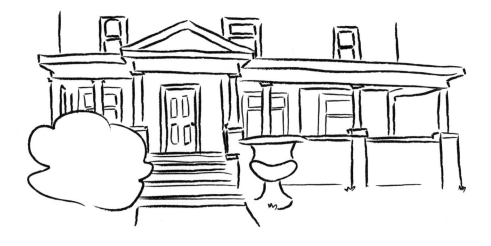

Finish the car.

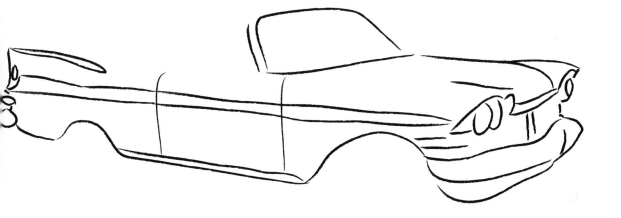

We've given you a pool and a driveway,
now design the rest of your dream house.

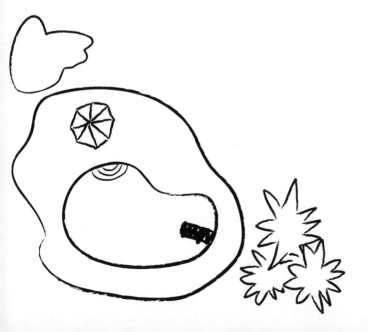

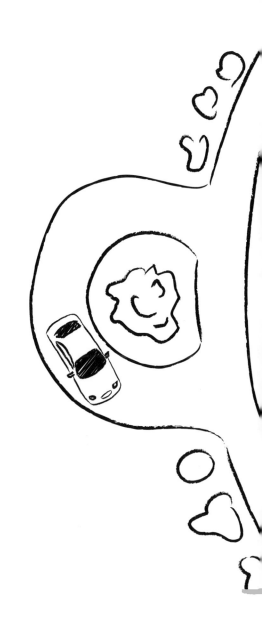

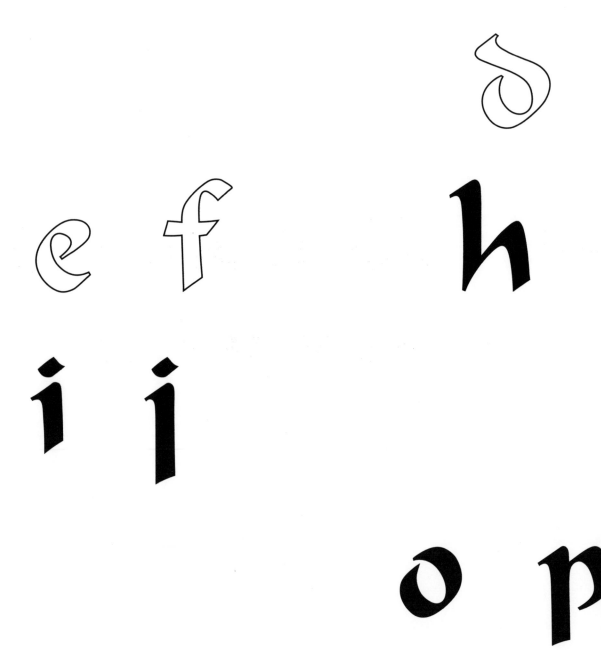

q r

w x y

Finish the pattern across the page. Feel free to add more detail, too.

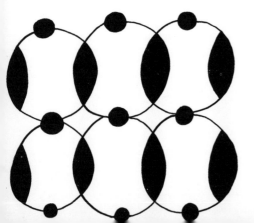

FREE
SPACE

What are the fish saying to each other?

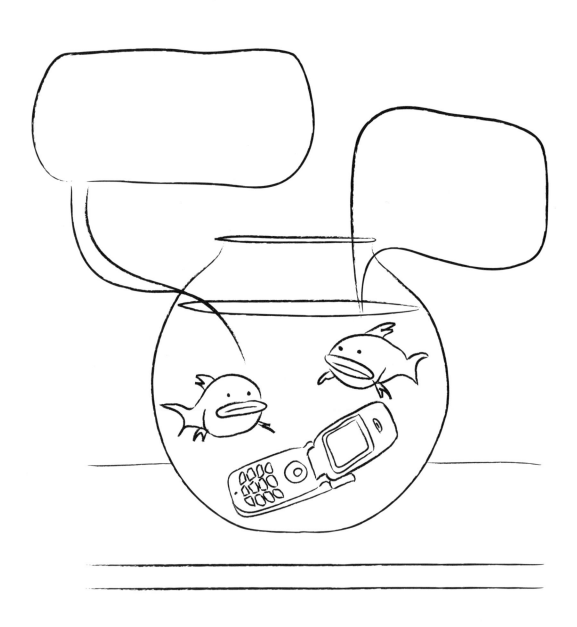

Finish the picture. Add your own words and shapes, too.

Draw what is going on inside this castle.

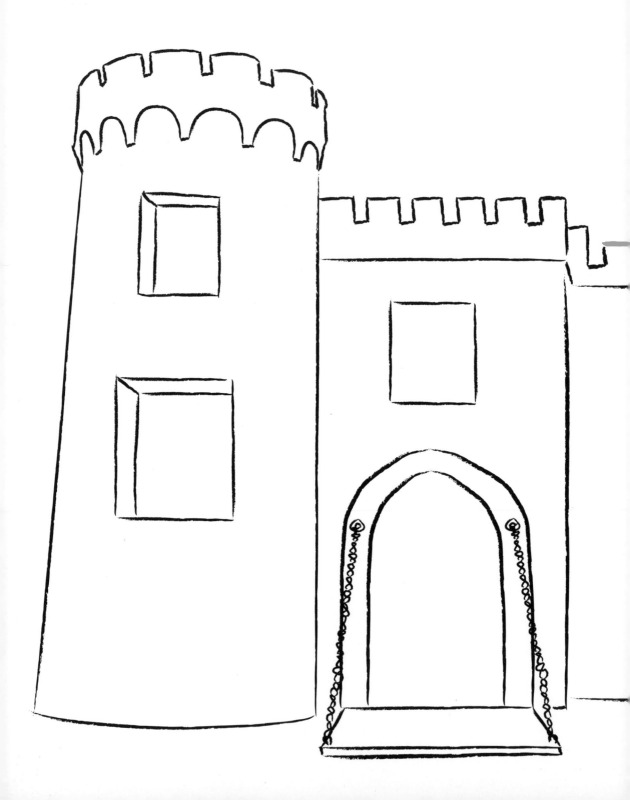

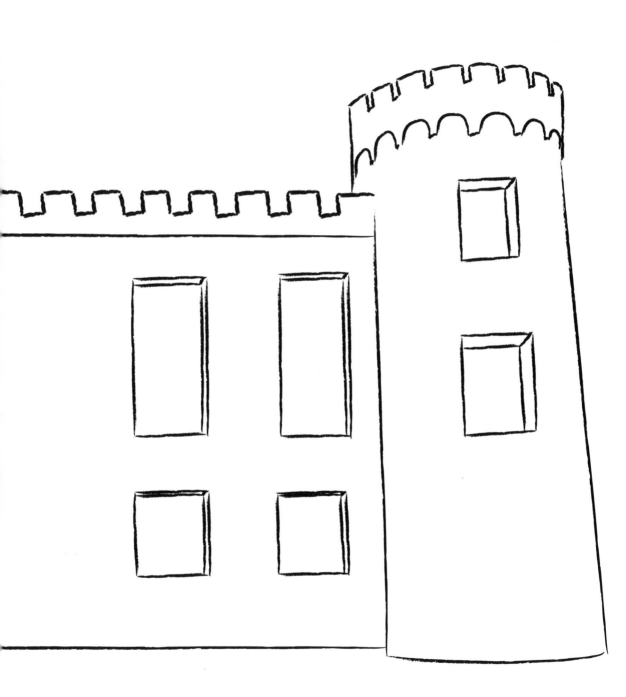

Add your own twist to this famous piece of art.

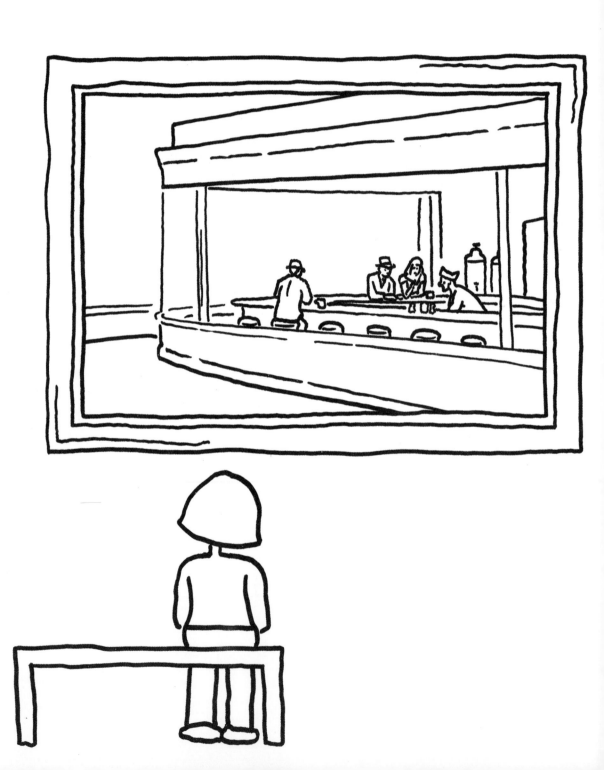

Now create your own masterpiece!

What do you see? Turn this squiggle into something else.

FREE
SPACE

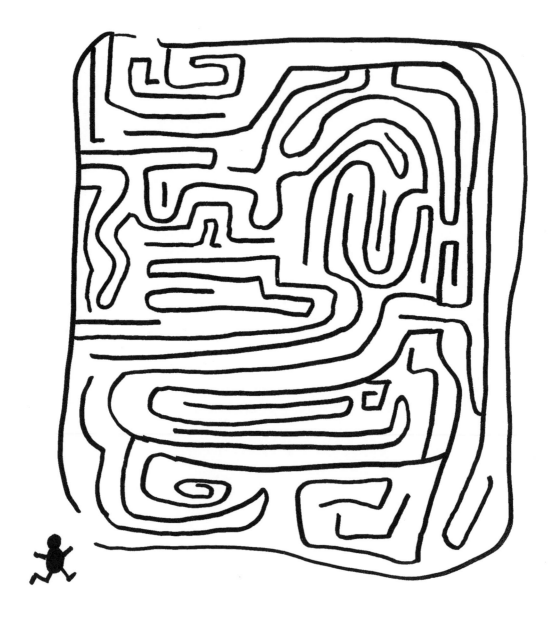

Doodle a prize at the end of this maze, then make your
way through it. You can doodle the surrounding area, too.

Finish drawing these pants and add a pattern.

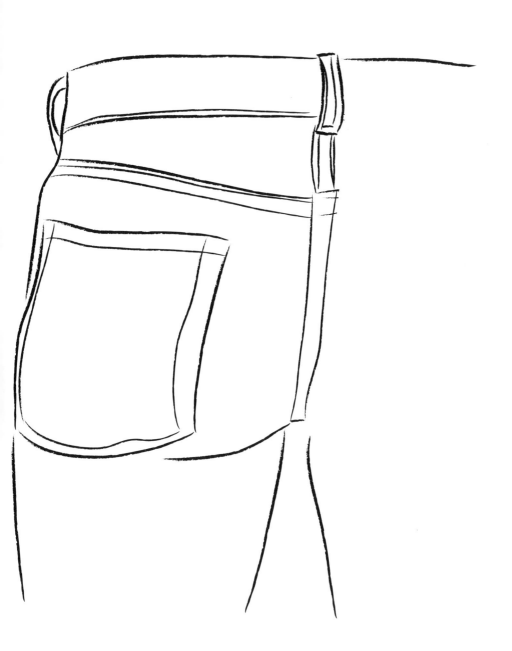

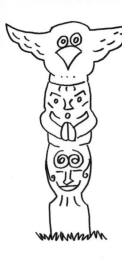

Like monuments, totem poles are built to symbolize various things. They often represent a particular person's life, an important legend, or a notable event. Create your own totem pole to tell the story of someone close to you, or to tell the story of an important event.

Finish the totem pole.

Finish the totem pole.

finish the totem pole.

Finish the scene, then write what the pigs are saying.

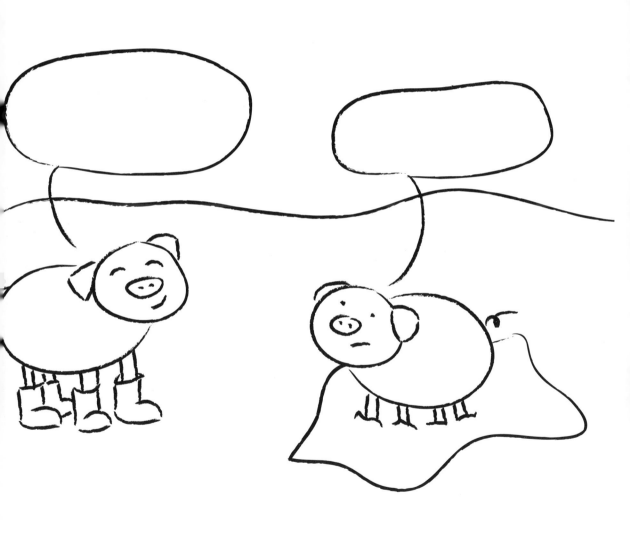

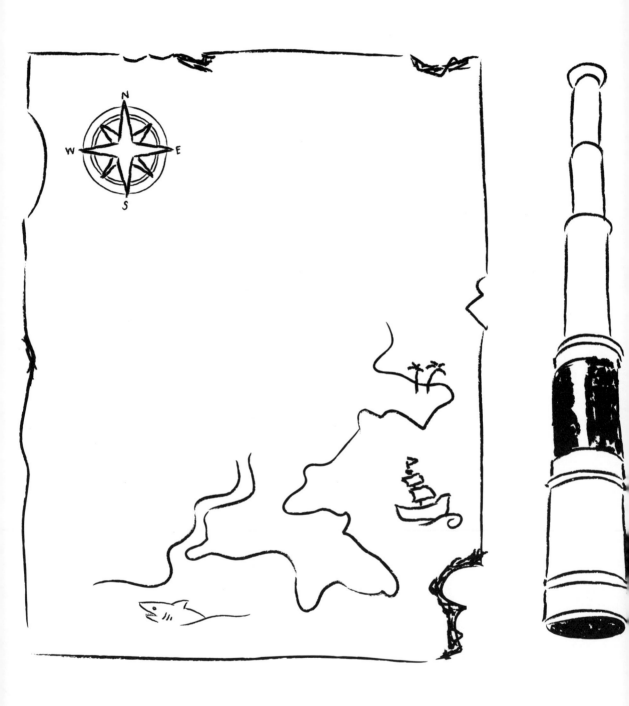

finish the map.

Doodle patterns on the party guests' clothes. Then add more detail to the scene, like paintings on the wall.

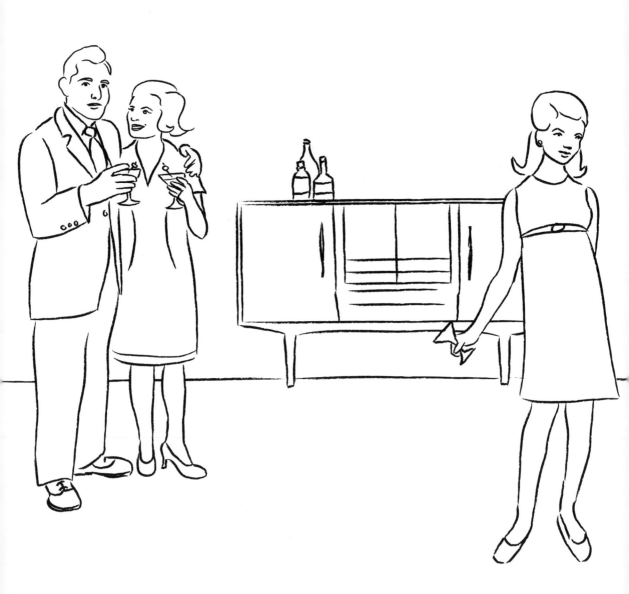

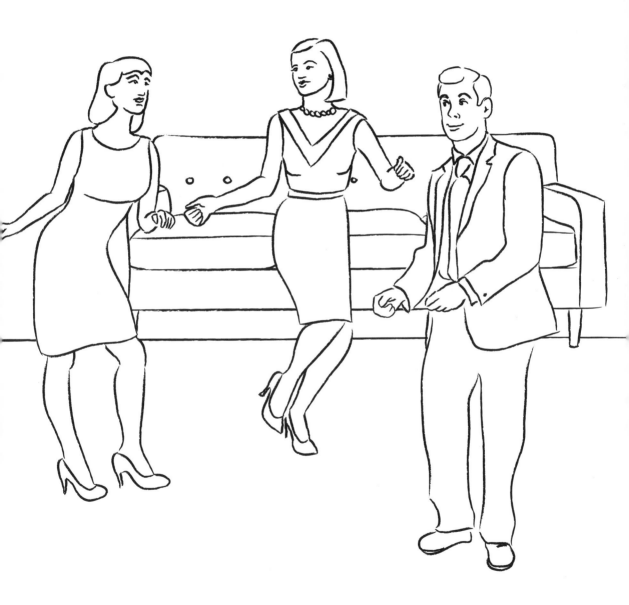

What do you see? Turn this squiggle into something else.

Add more dimension and shadows to the house and the chairs.

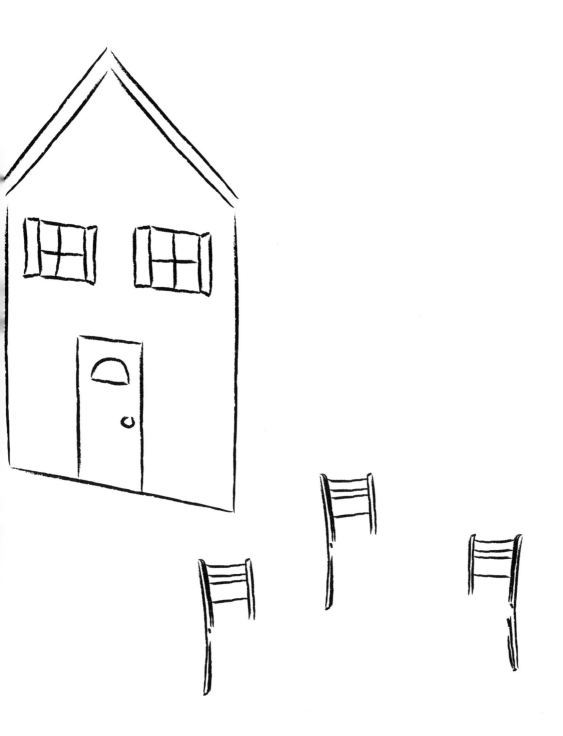

finish the doodle.

Finish the doodle.

Finish this picture. Add your own words and shapes, too.

Finish the doodle.

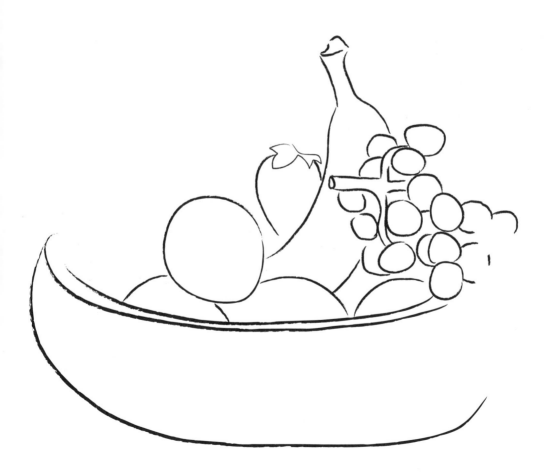

Add your own twist to this famous piece of art.

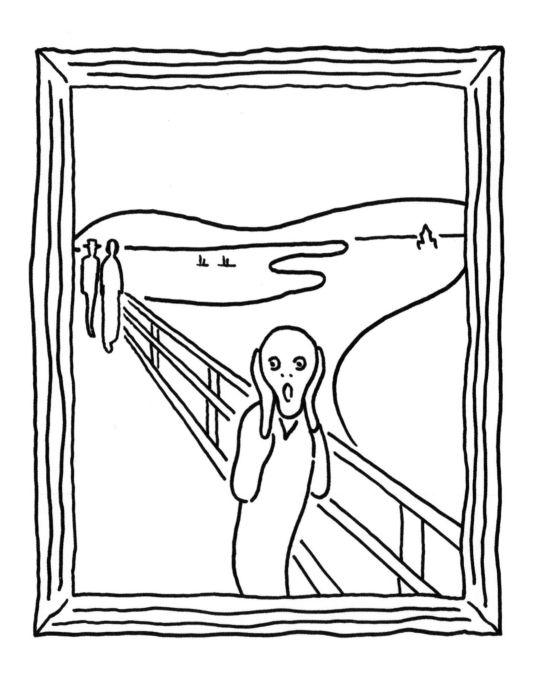

Now create your own masterpiece!

Fill the bus with commuters.

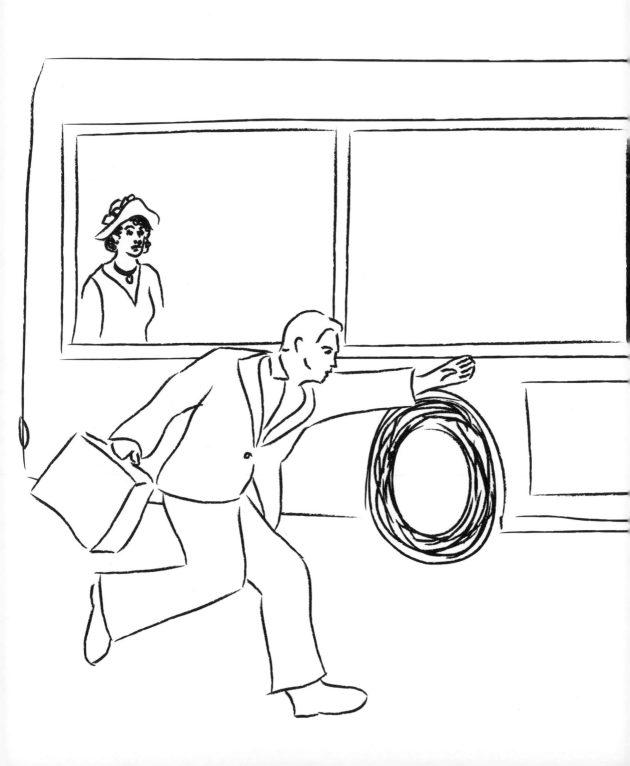

Finish the pattern across the page. feel free to add more detail, too.

FREE
SPACE

Finish the amusement park map.

Finish the alphabet.

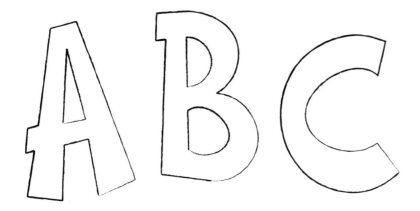

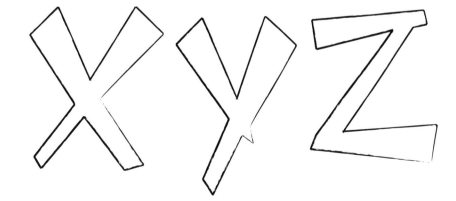

Draw what is going on inside the department store.

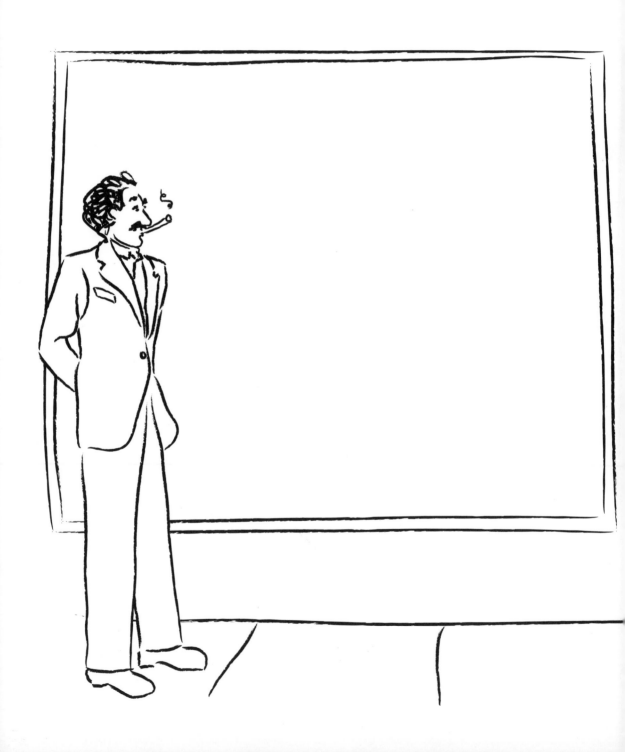

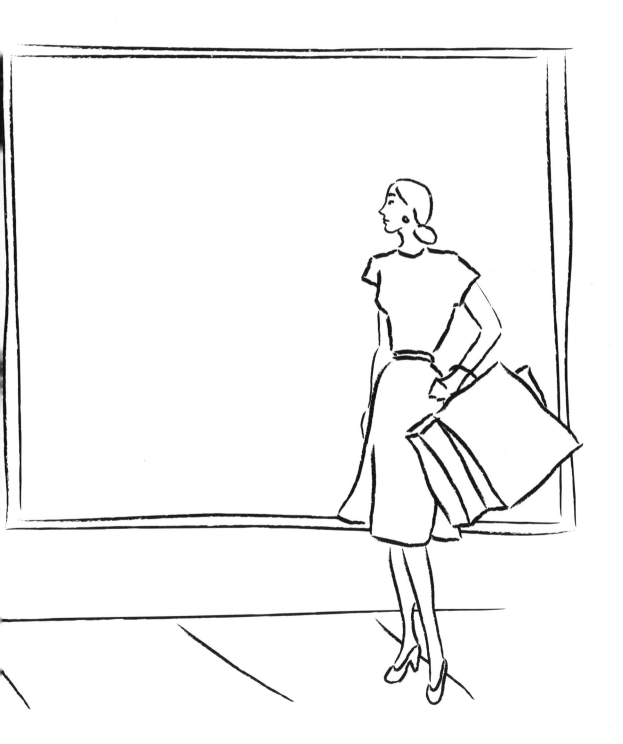

What is the dog thinking?

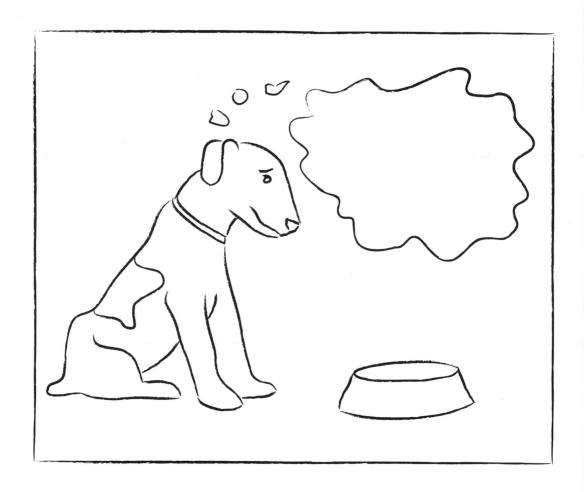

What do you see? Turn this squiggle into something else.

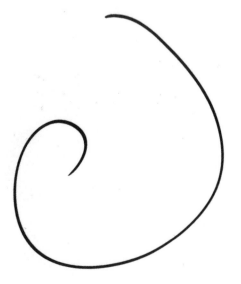

Finish drawing the maze. Then make your way through it.

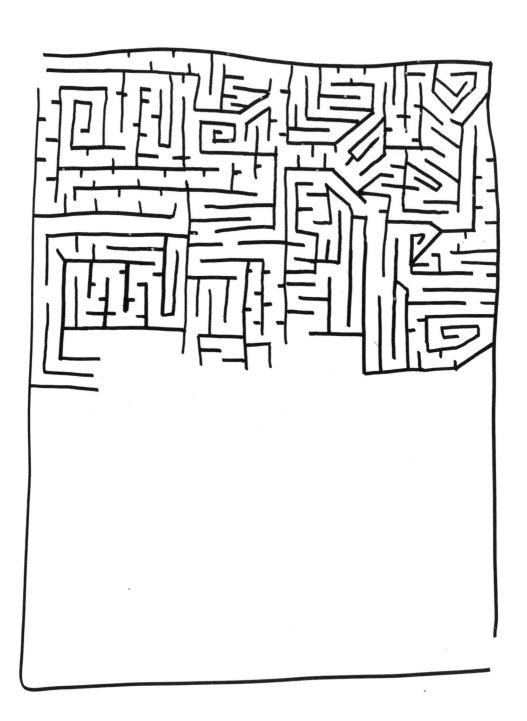

Add your own twist to this famous piece of art.

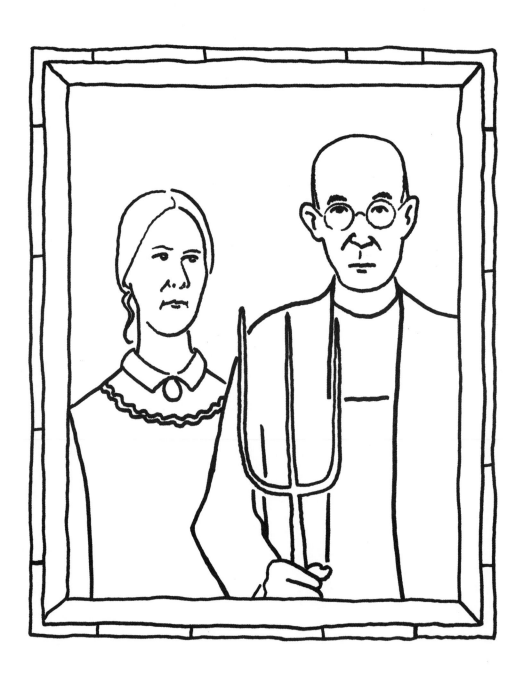

Now create your own masterpiece!

Create some hairstyles for these heads.

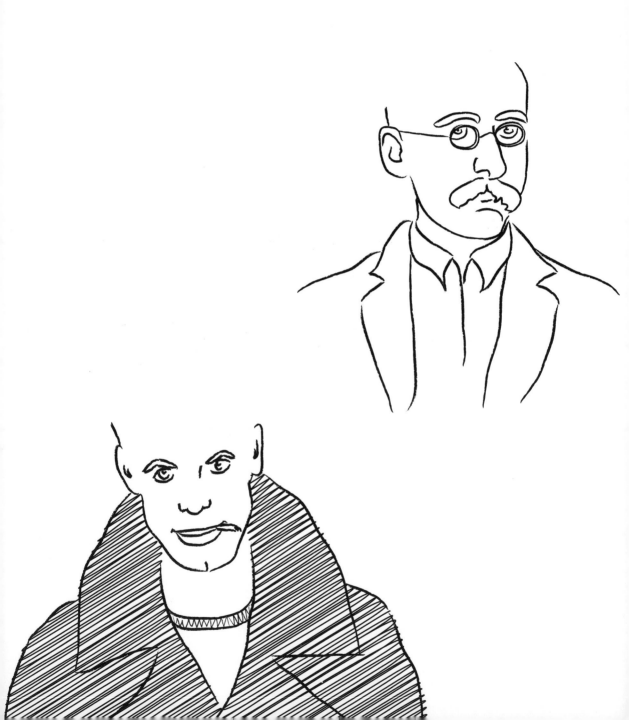

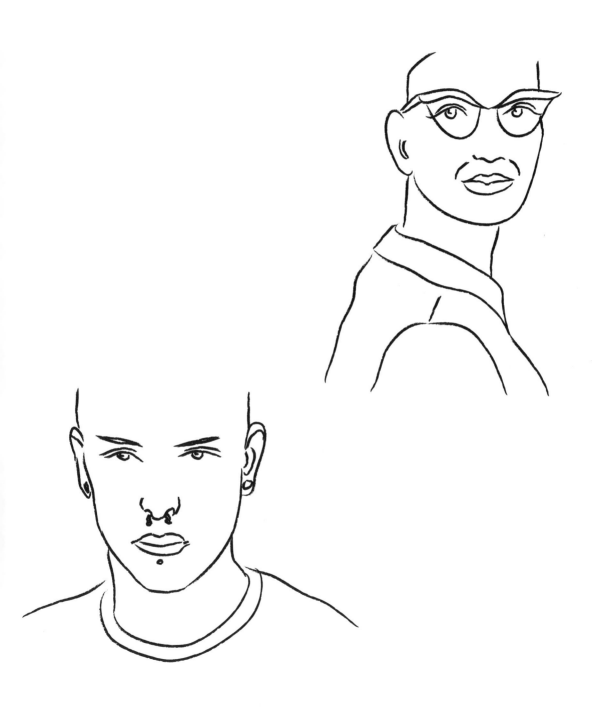

finish the drawing.

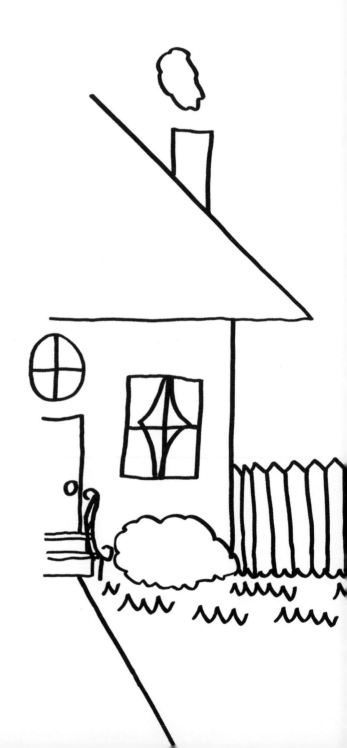

finish the drawing.

What are these people really thinking?

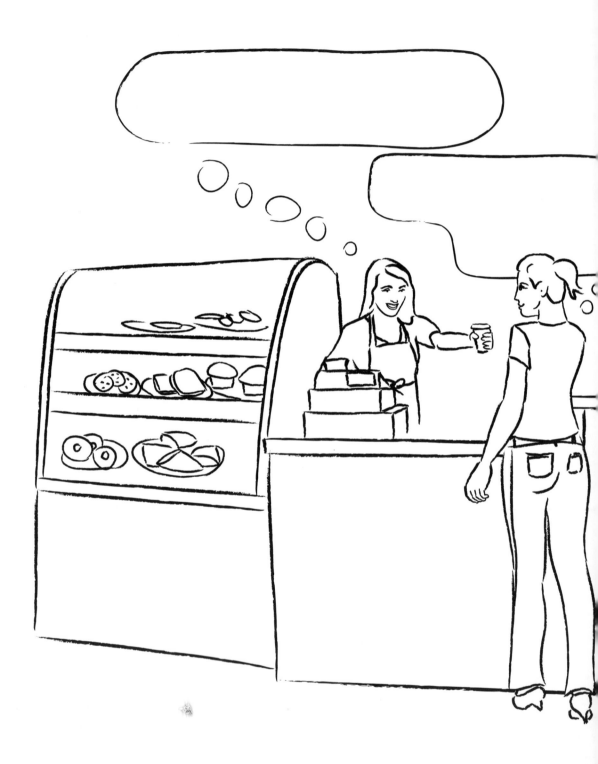

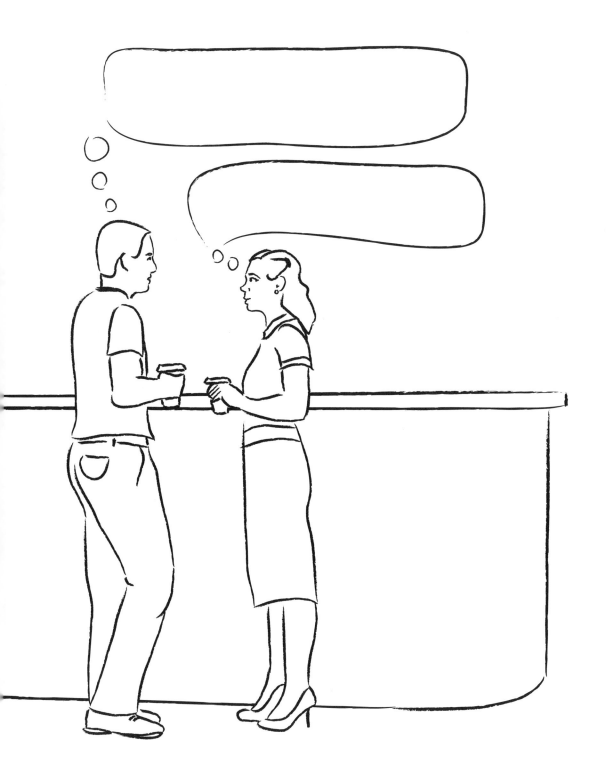

Create your own gargoyle.

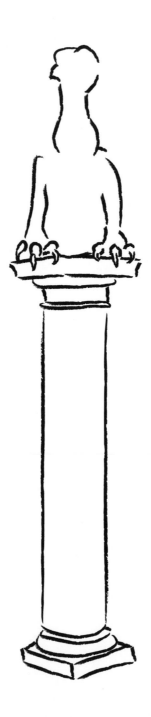

Draw the city below this gargoyle.

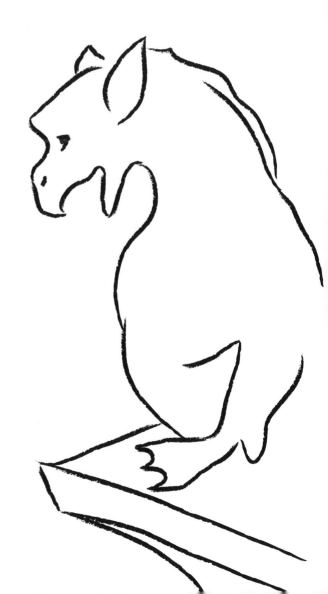

Create your own gargoyle.

Doodle the view below the gargoyle.

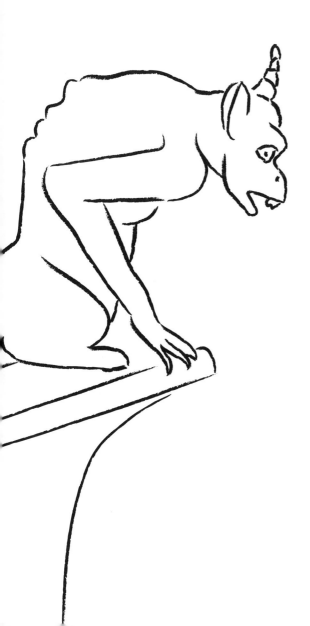

Finish the pattern across the page. Feel free to add more detail, too.

What do you see? Turn this squiggle into something else.

Finish drawing the maze. Then make your way through it!

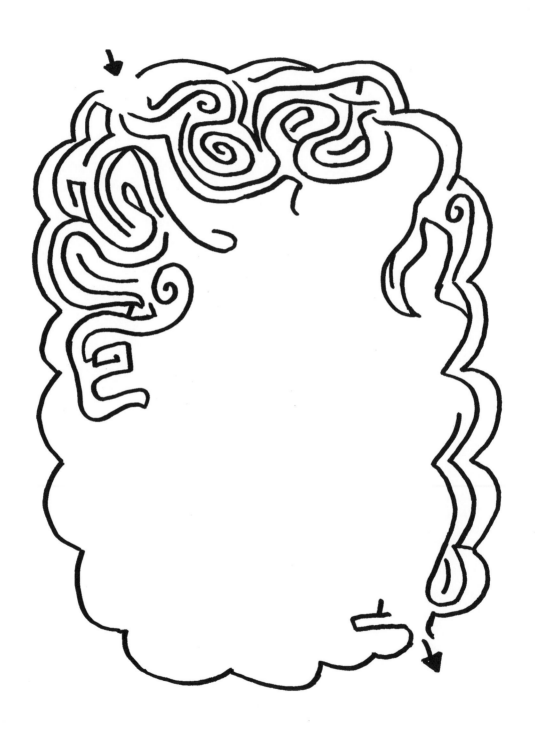

FREE SPACE

Draw what is going on inside this building.

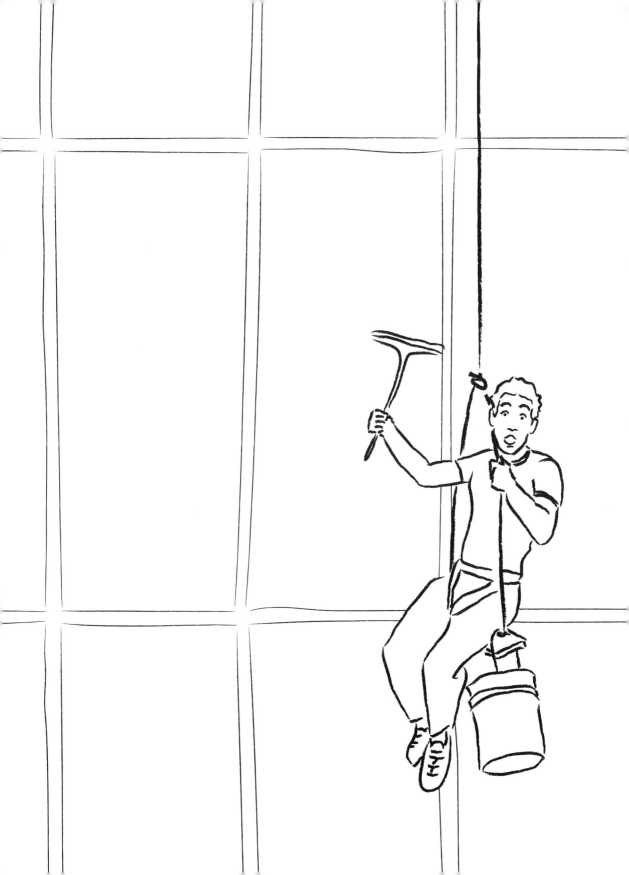

Doodle some party clothes. Then finish the holiday scene.

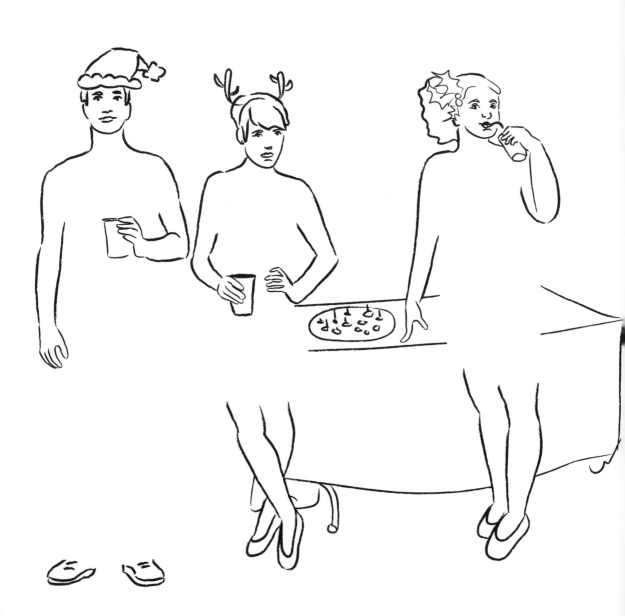

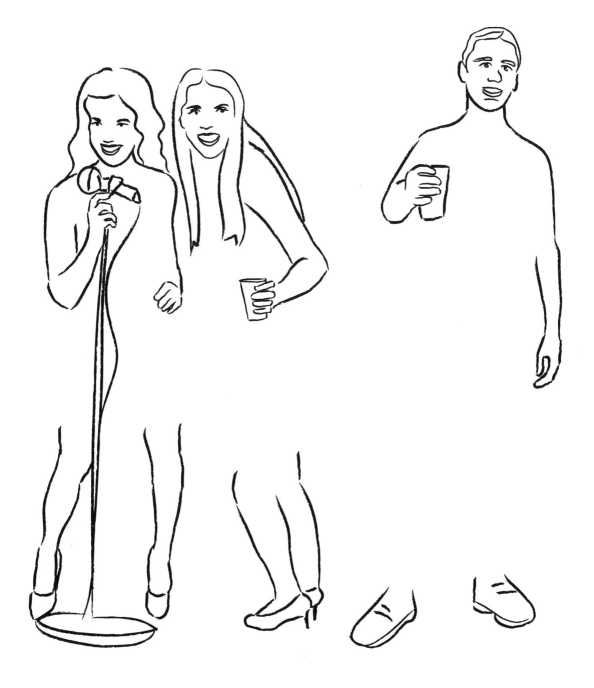

What is the man saying?

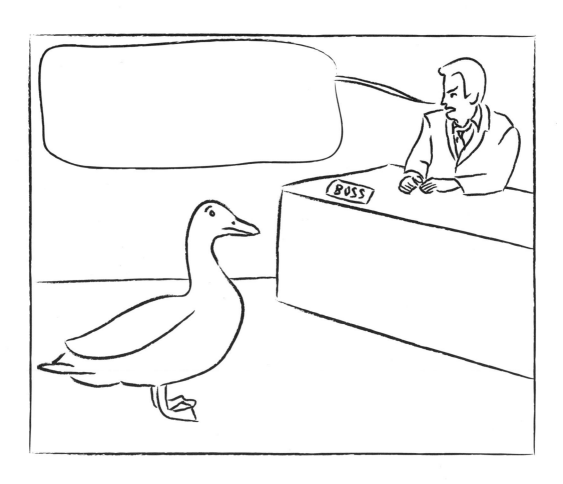

What's inside the gym bag?
You can also add a pattern or finish the scene.

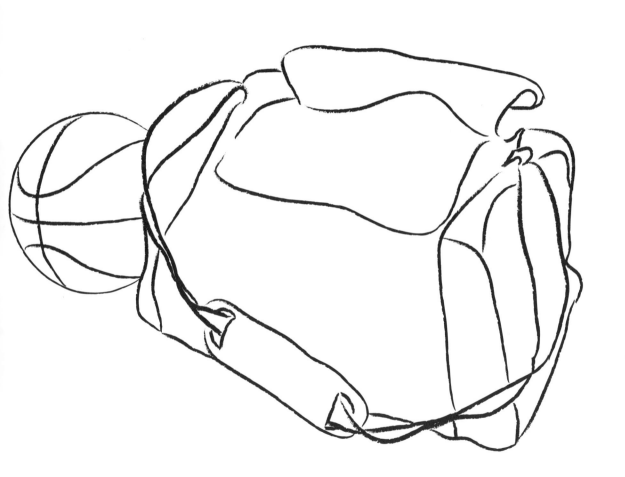

Finish the map.

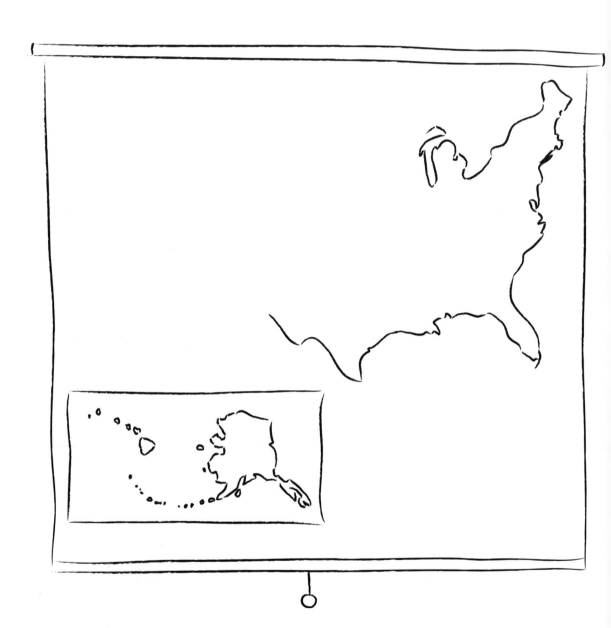

FREE
SPACE

Draw the faces to show the emotions listed.

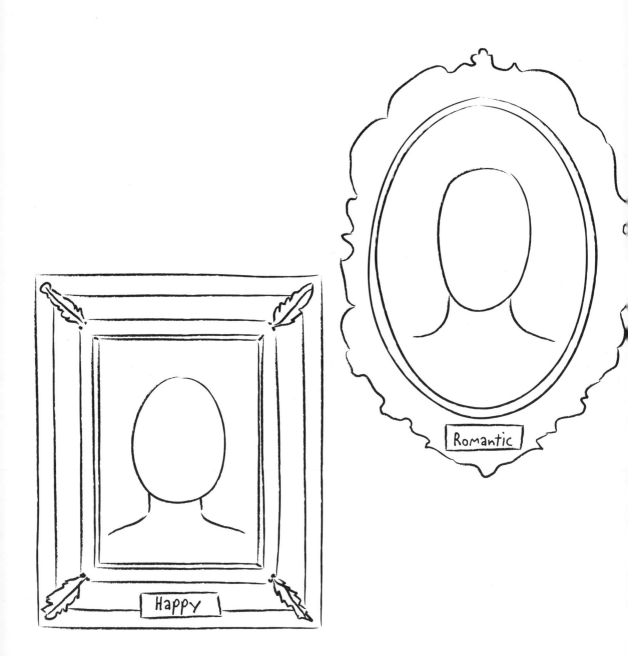

Happy

Romantic

Confused

Angry

Finish the pattern across the page. Feel free to add more detail, too.

Add dimension and shadows to this
box of chocolates. Then fill the box.

Give the computer a screen saver. Then finish doodling the scene.

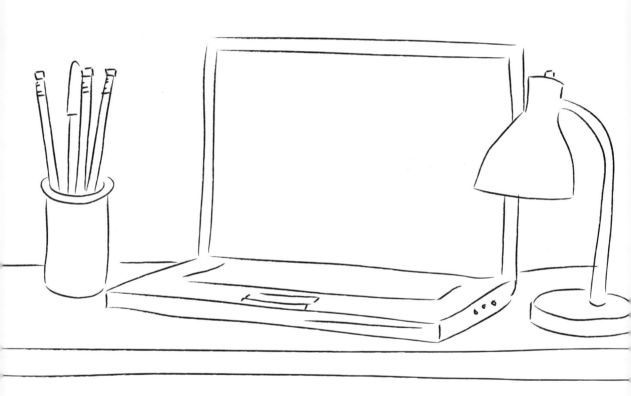

What do you see? Turn this squiggle into something else.

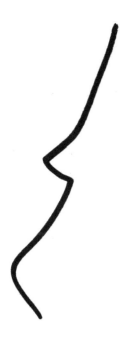

Finish drawing these hands.

FREE
SPACE

Add your own twist to this famous piece of art.

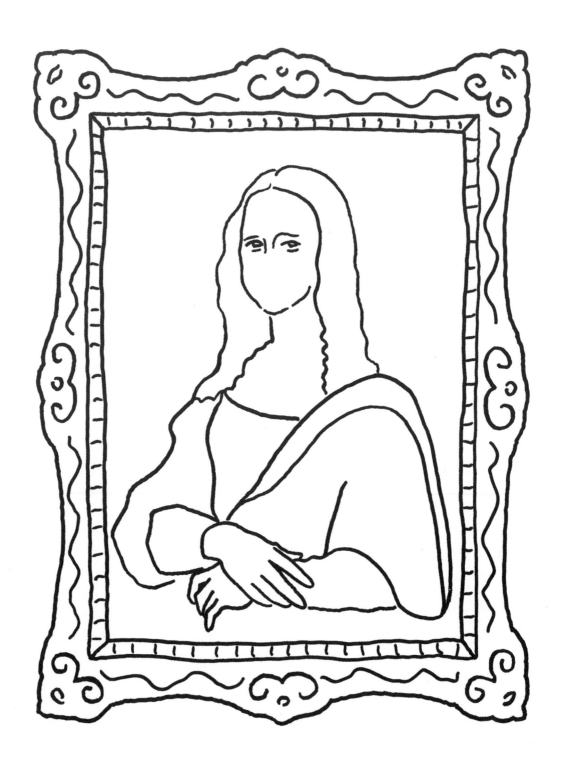

Now create your own masterpiece!

Finish this trail of dropped groceries.

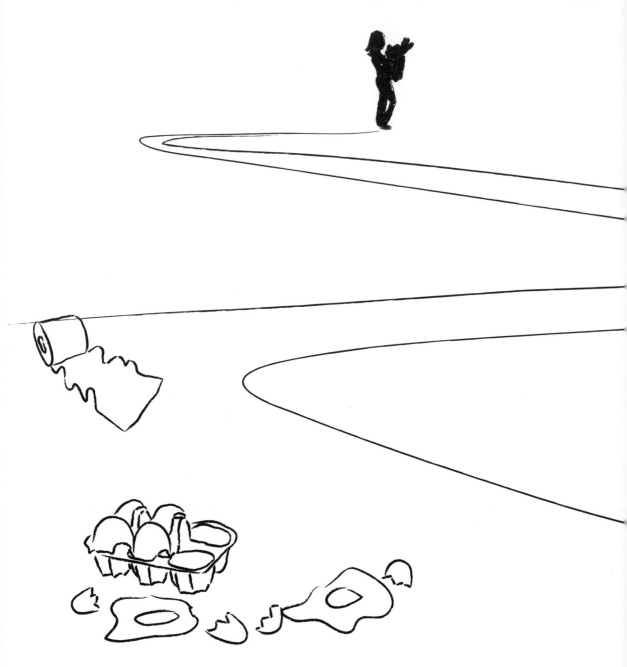

What is the shark saying?

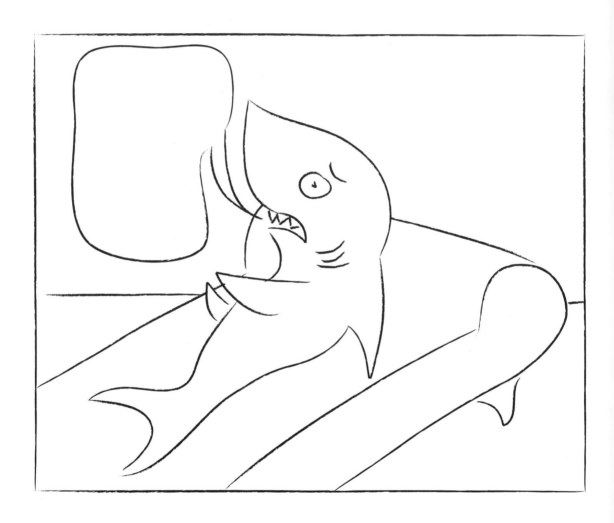

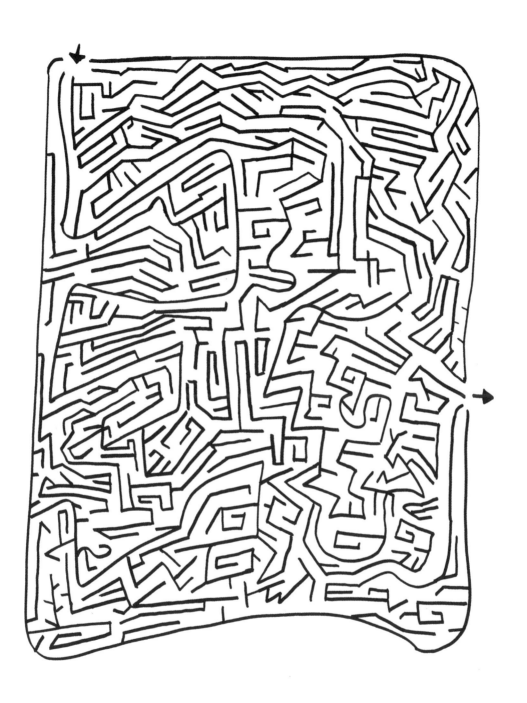

Doodle the scenery surrounding the maze.
Then make your way through it.

Finish the pattern across the page. Feel free to add more detail, too.

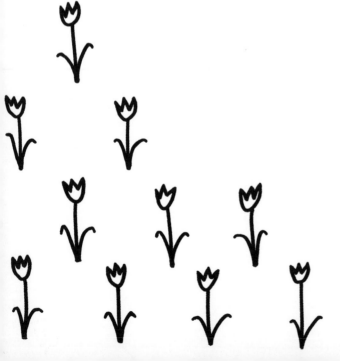

FREE SPACE

Give the woman more tattoos.

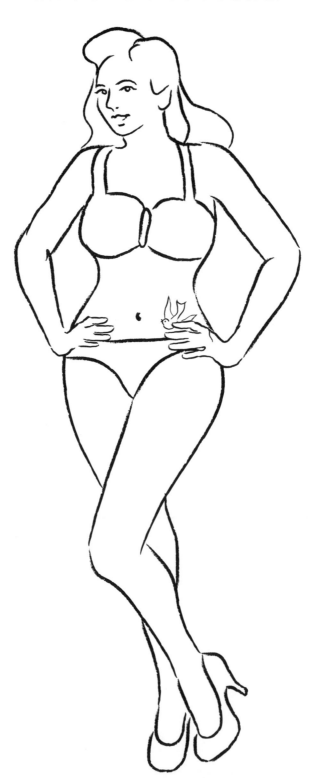

Finish the picture. Add your own shapes and words, too.

TREETREETREETREETREETREE
TREETREE APPLE TREETREE
TREE APPLE TREETREE APPLE TREE
TREETREETREE

APPLE

TRUNKTRUNKTRUNK
TRUNKTRUNKTRUNK

Finish the scenic doodle.

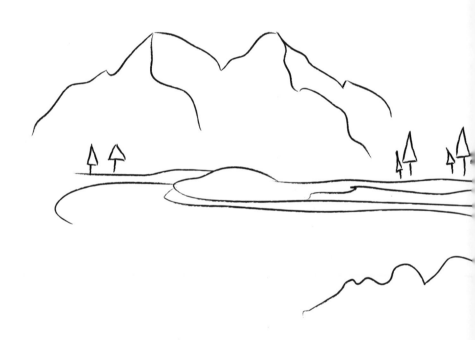

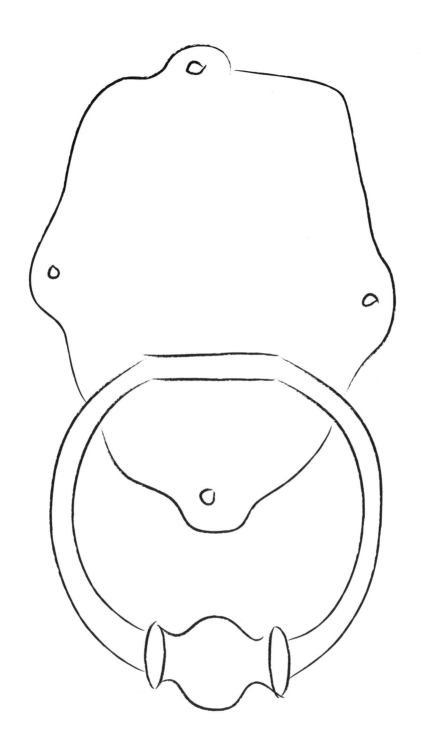

Design your own doorknocker.

Draw what is going on inside this hotel.

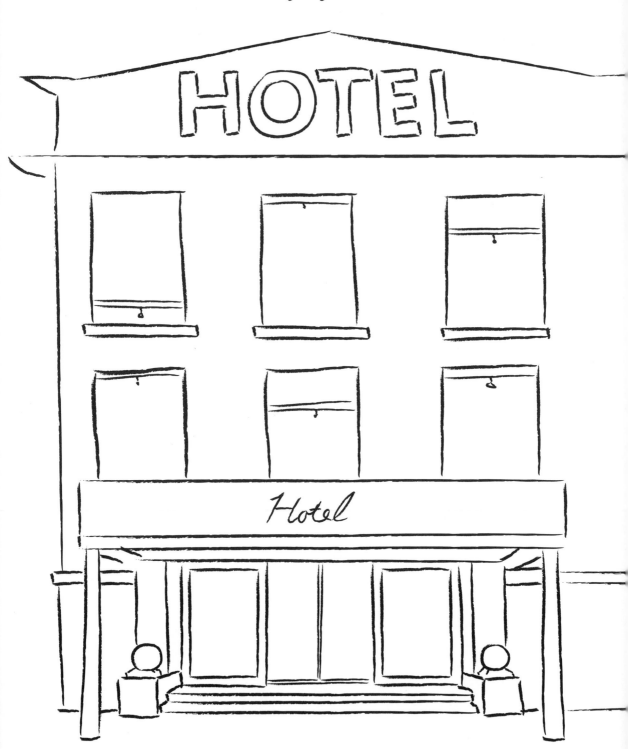

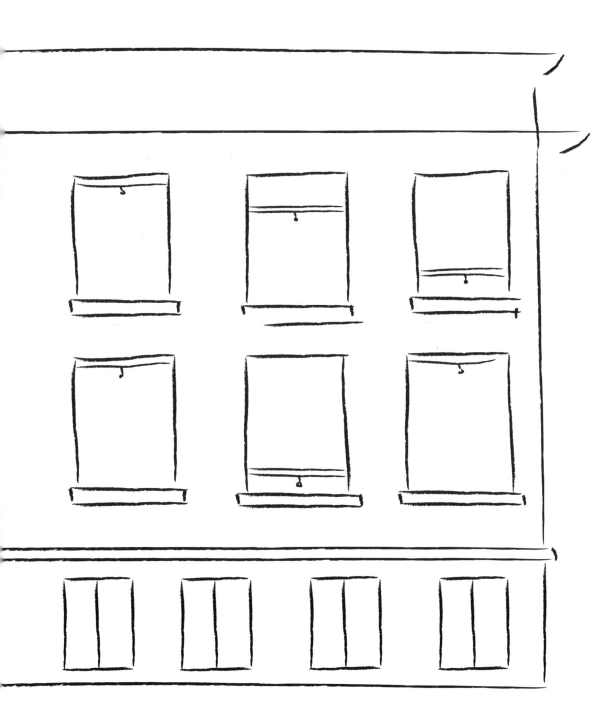

Finish the doodle.

FREE
SPACE

Doodle some people riding the roller coaster.
Then finish designing the ride.

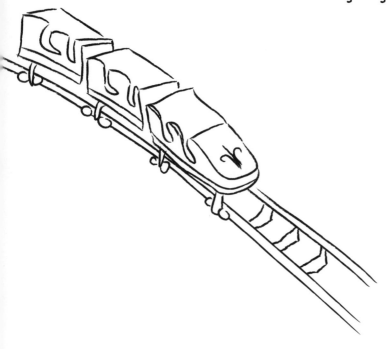

Doodle the interesting characters in the waiting room.
Then finish the scene.

Finish the doodle.

Create designs for these coins.

Finish doodling the purse. Is there something inside?

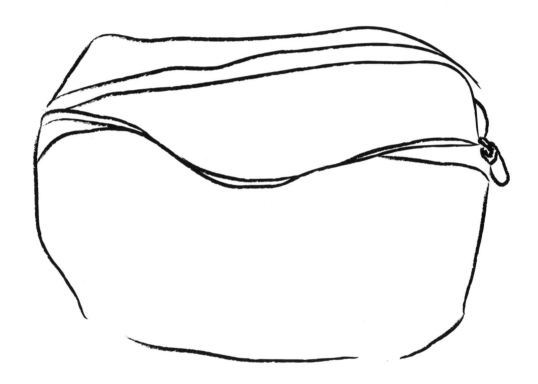

FREE
SPACE

Finish party scene. Then draw patterns on the party guests' clothes

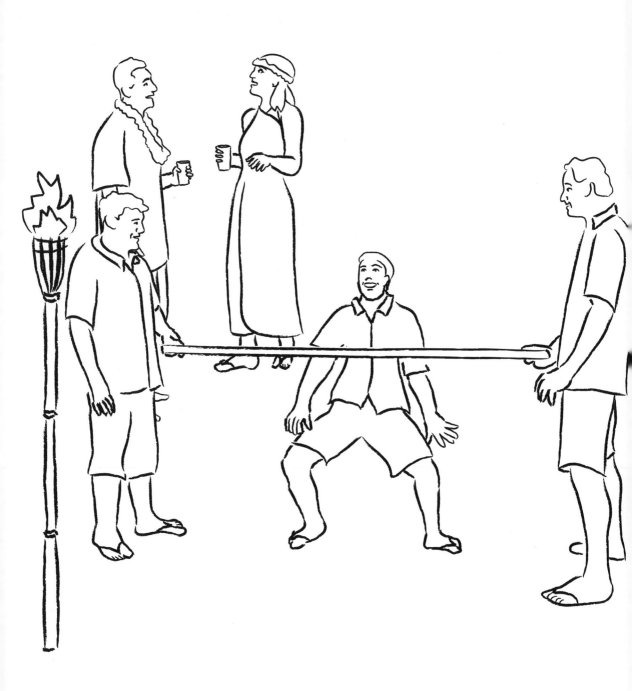

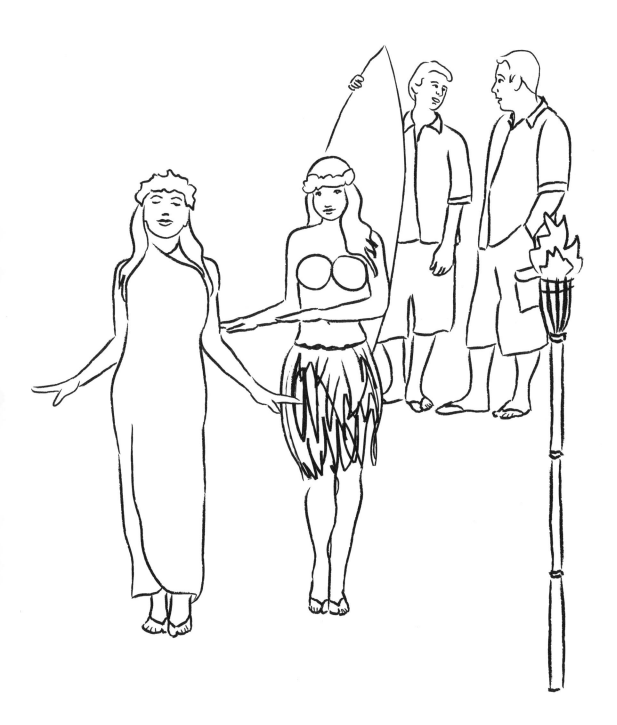

Write a funny caption for what is happening in this cartoon.

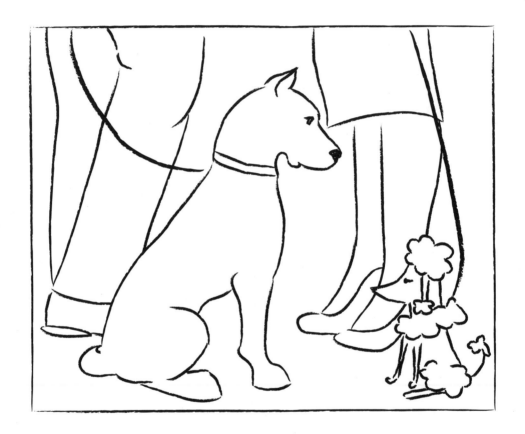

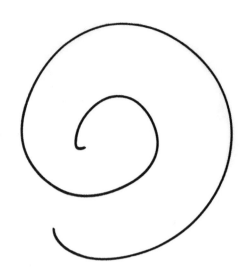

What do you see? Turn this squiggle into something else.

Doodle some covers for the movies.

Add dimension and shadows to this bookshelf, then finish the scene.

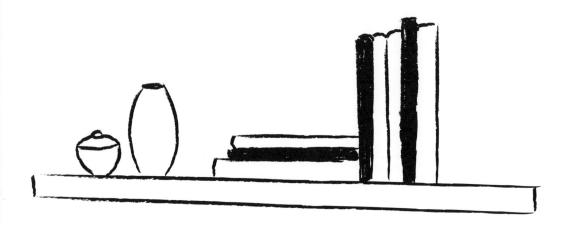

FREE
SPACE

Finish doodling this outer space scene.

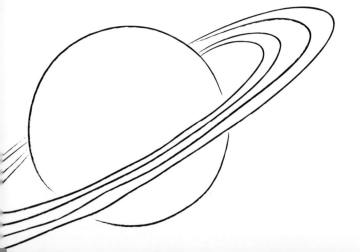

Finish the family portraits.

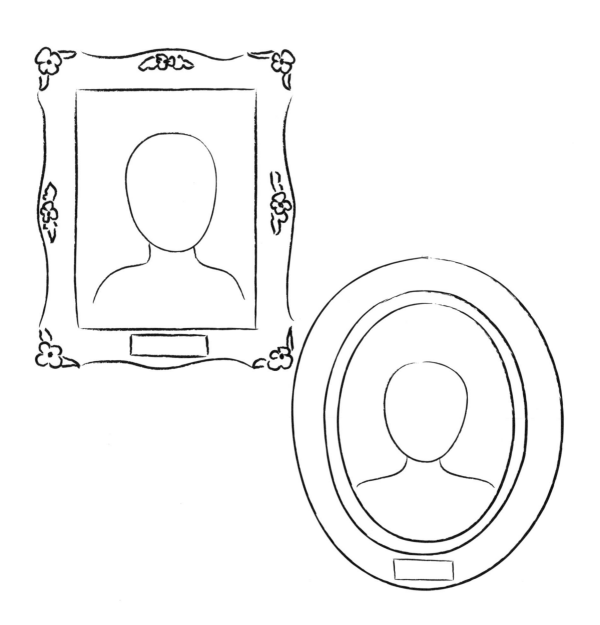

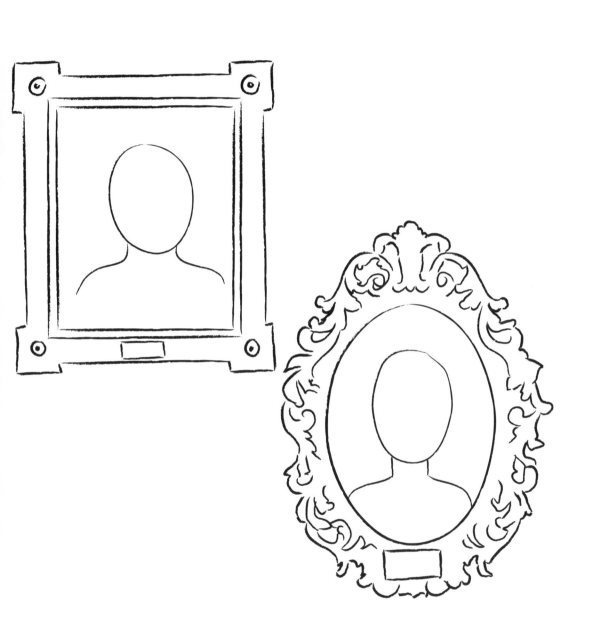

What is he saying?

Finish drawing these feet.

Design a screen saver. Then finish the scene.

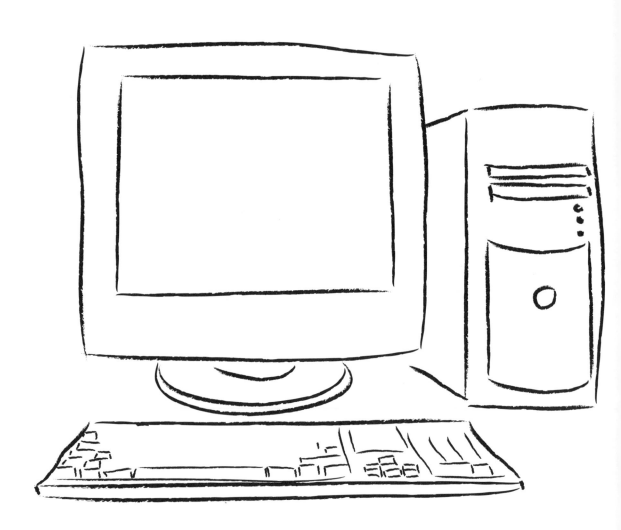

FREE
SPACE

Add some dimension and shadows
to the coffee mug and the stack of books.

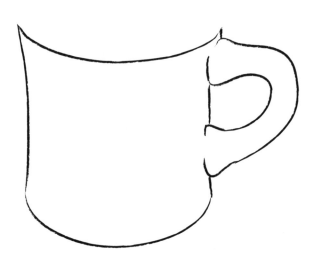

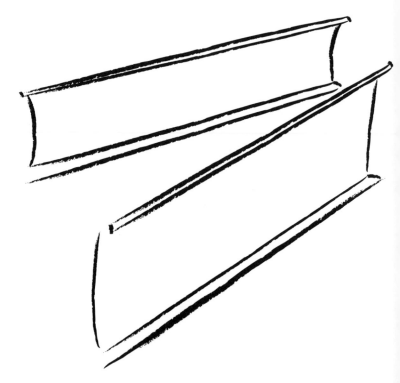

Finish the pattern across the page. Feel free to add more detail, too!

Finish drawing the rest of the street.
Add buildings, people, and cars.

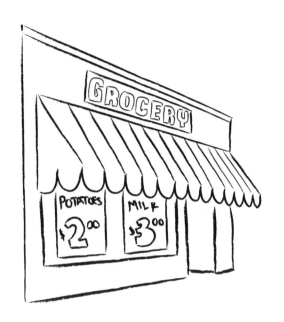

Draw what is going on inside the house.

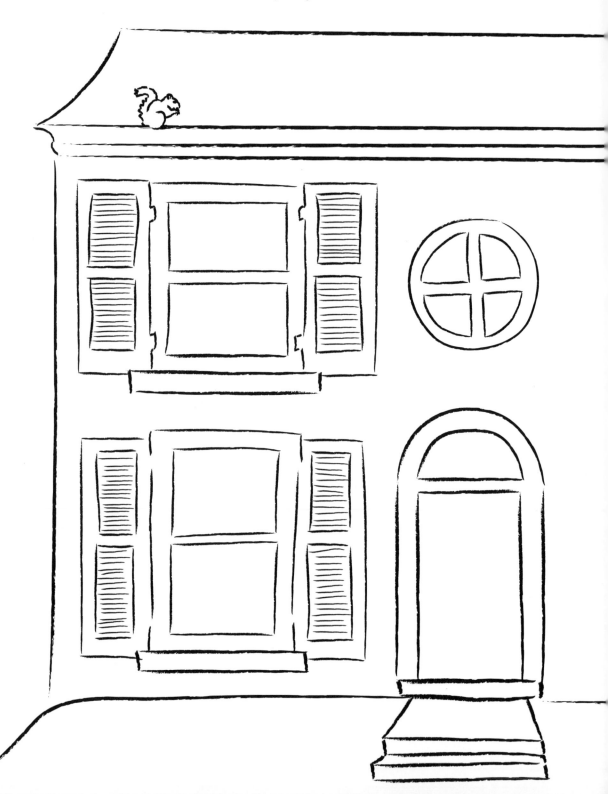

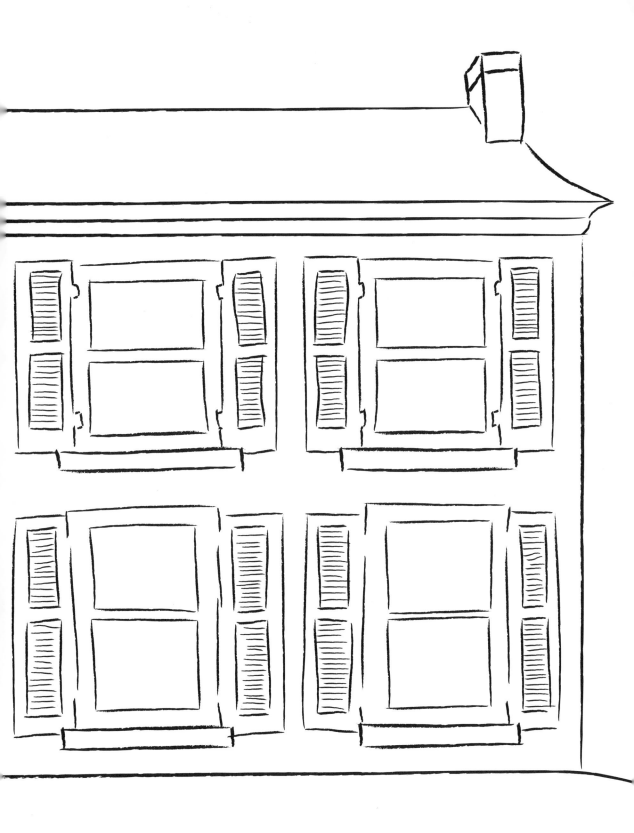

Finish the picture. Add your own words and shapes, too.

FREE
SPACE

Give the sailor more tattoos.

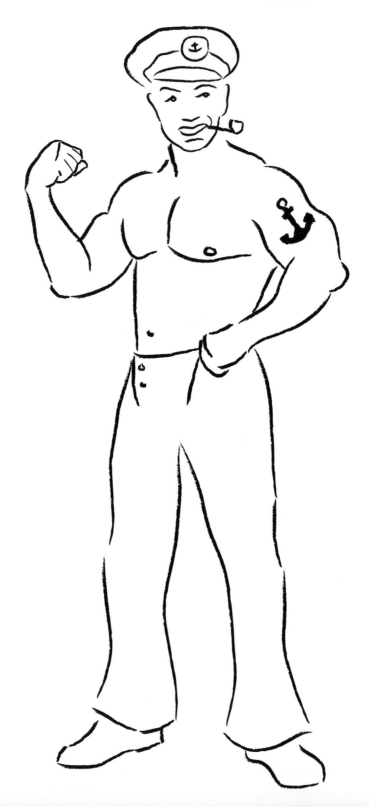

inish the pattern across the page. feel free to add more detail, too!

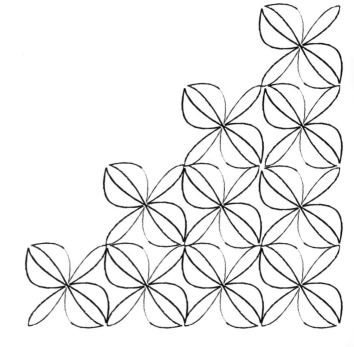

Finish doodling the meteorologist.
Then draw the weather on the screen.

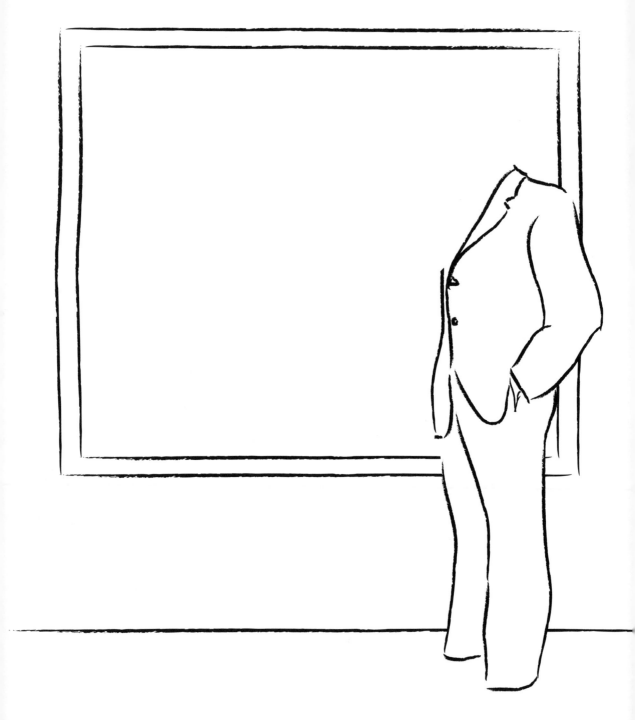

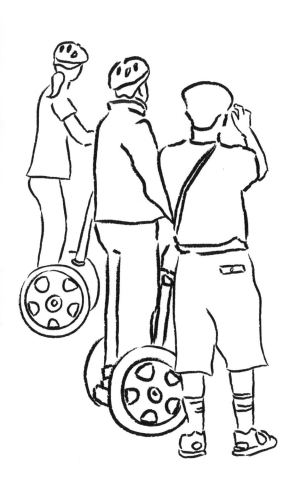

Doodle the tourist attraction.

Dress up this desk and add a screensaver design.

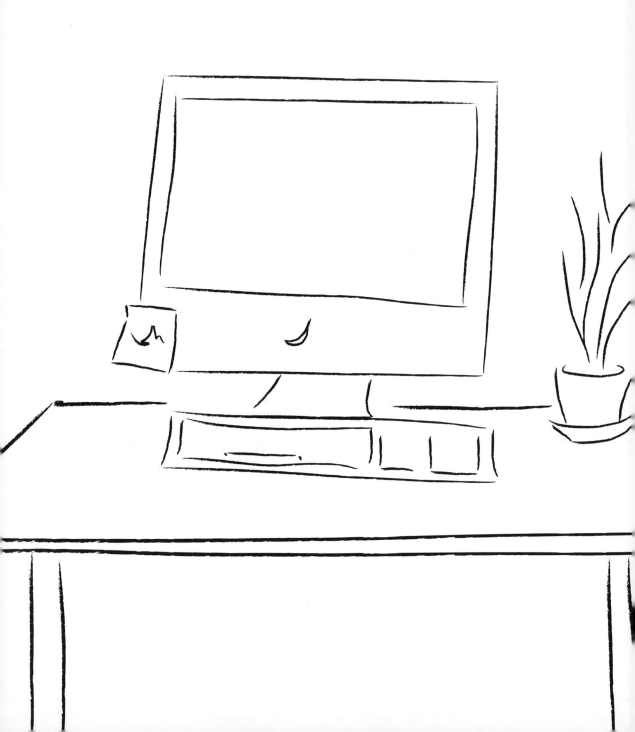

Finish the tunnels in the ant farm.
Then add some ants or other creepy-crawlies.

Write a caption for this cartoon.

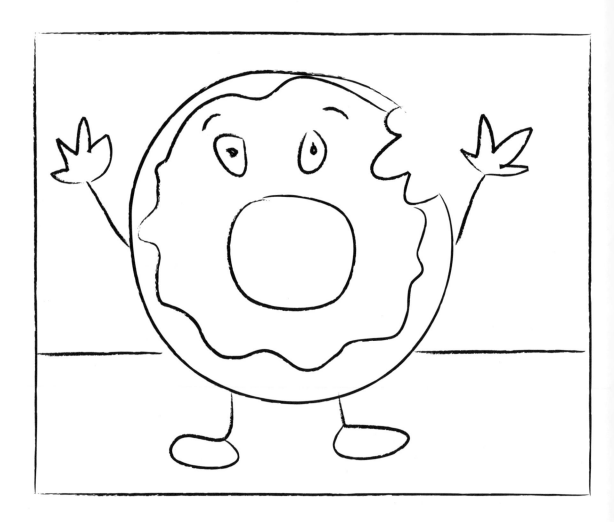

FREE
SPACE

Finish drawing this harbor scene.

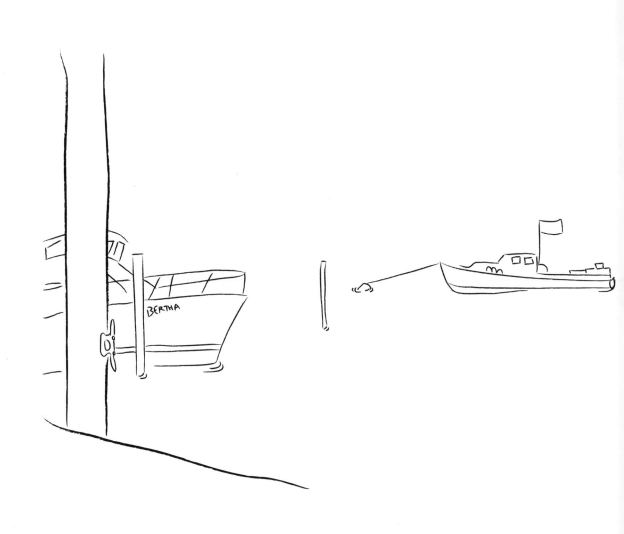

Finish drawing this backpack and add a pattern.
Is there something inside?

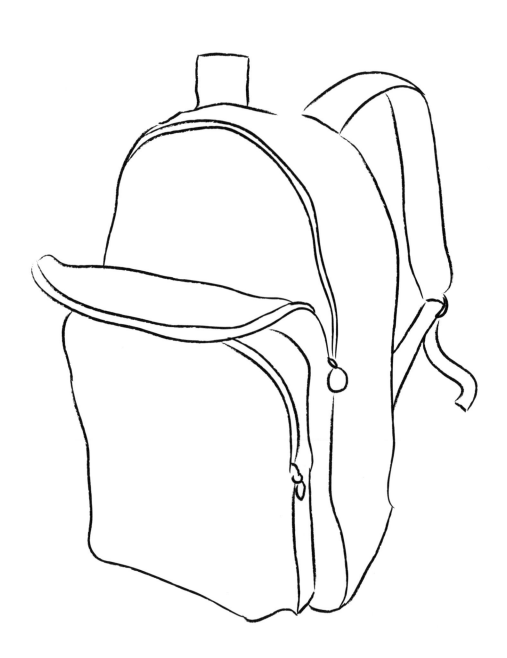

What do you see? Turn this squiggle into something else.

Finish the pattern across the page. Feel free to add more detail, too!

Finish drawing the grid of the city.

Finish the structure. Add tourists and scenery.

nish the pattern across the page. Feel free to add more detail, too!

Draw the faces to show the emotions listed.

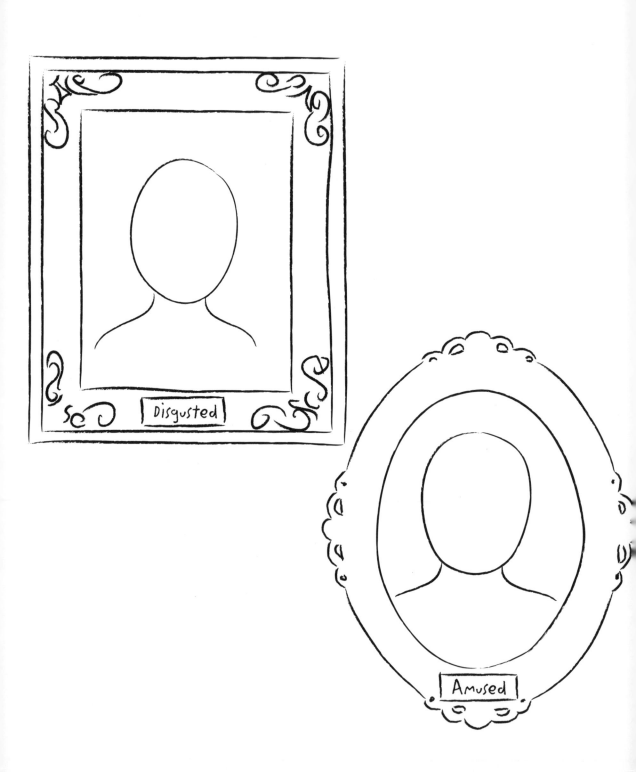

Disgusted

Amused

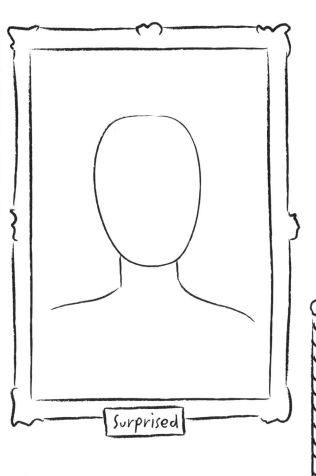

Surprised

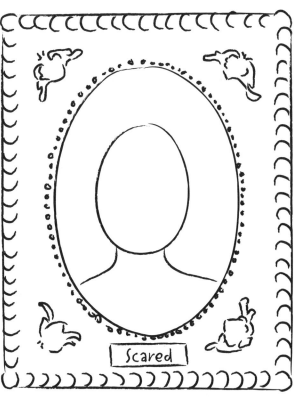

Scared

Finish the alphabet.

Finish the scene. Add your own shapes and words, too.

FREE
SPACE

Finish the cartoon, then write a caption.

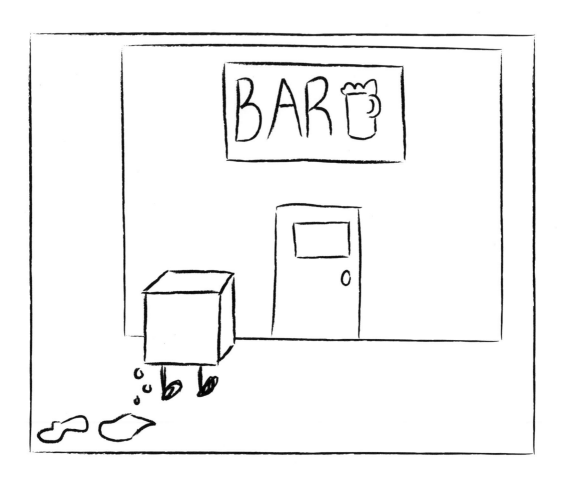

Finish the tunnels in the ant farm.
Then add ants or other creepy-crawlies.

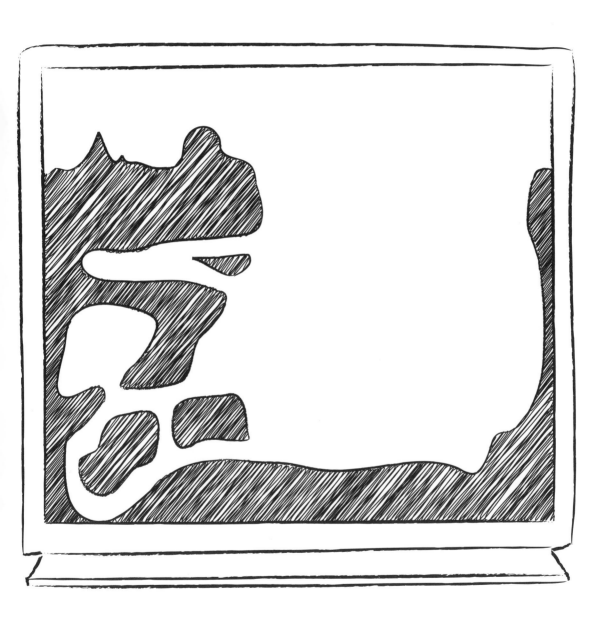

Finish drawing these faces.

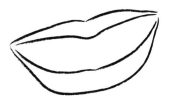

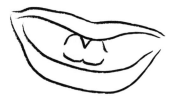

Finish drawing the box. Add a pattern. Is there something inside?

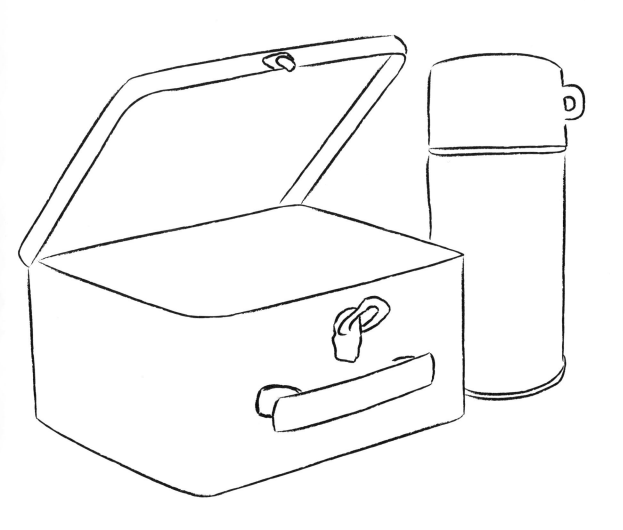

Finish the pattern across the page. Feel free to add more detail, too!

FREE
SPACE

Draw what is going on inside this hospital.

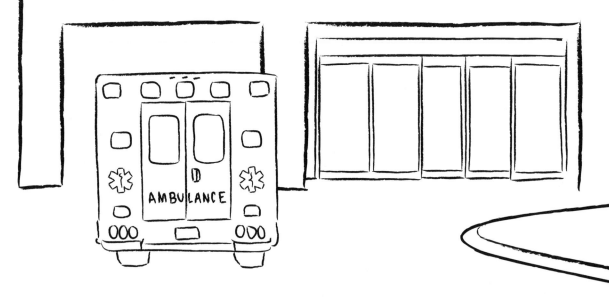

EMERGENCY

AMBULANCE

What are the penguins thinking?

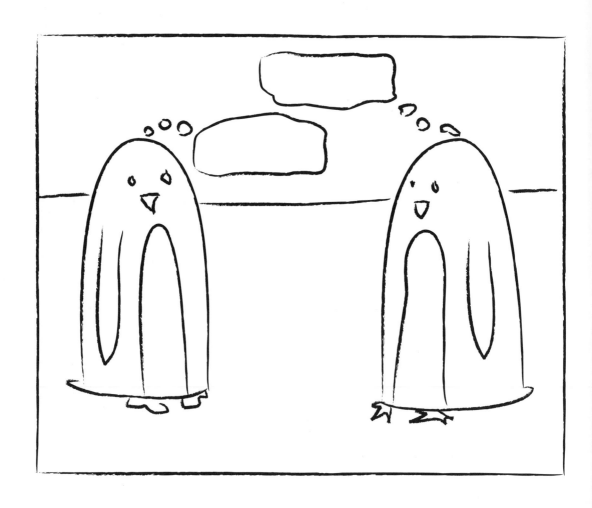

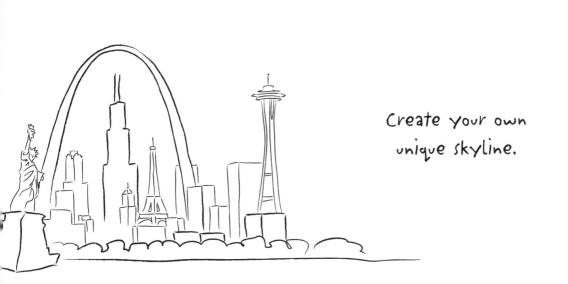

Create your own
unique skyline.

Finish the alphabet.

t u v

finish drawing the maze. Then make your way through it!

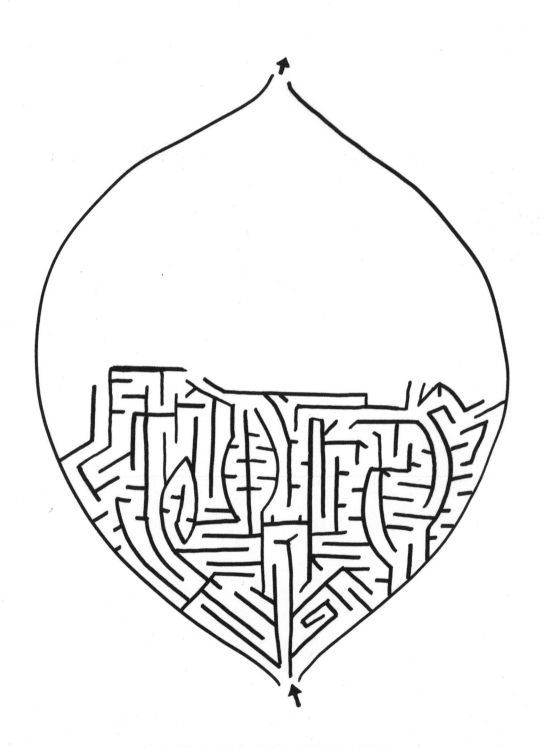